Two Cities

David Zwirner Books

ekphrasis

Two Cities
Cynthia Zarin

For Virginia Cannon

Contents

Serene

In the first place, it was the wrong time. It was June, and starting in April, Venice is jammed. Petrarch, in his letters, described the Piazza San Marco as so crowded that if you dropped a grain of millet there it would never reach the pavement. The first time I went to Venice was in July, a disaster—nothing more than a glimpse of the city called La Serenissima. But the next time it was December. Then, I was just married. We stayed at the Hotel La Fenice and heard singers practicing at the opera house through the window, which let in a tongue of cold.

In the second place, I did not want to go at all. My life had come to seem like a series of extravagances punctuated by episodes of extreme austerity. Over the past months, I had given my heart away to someone who immediately lost it, taken it back from someone who loved me, and set it off like a top in another direction and watched it teeter crazily. These things happened almost at once. The result was that I was going to Venice alone. I think I had known I would all along. The ostensible reason was to write a story for a magazine. The magazine ran a column in which writers wrote about a city they knew. This suited me, as I rarely go to new places but instead retrace my steps, looking for breadcrumbs I left long ago that were since eaten by birds. Venice was not on the list of cities and towns that others had chosen: Istanbul, Port-au-Prince, Reykjavík, Santa Monica. I could say anything I liked in one to two thousand words.

In any case, I had been thinking about going to Venice all winter. It was as if something I had lost, or was looking

for, was there. I had just published a book about a life that now seemed like a long dream, in which a family of children grew up in a tall drafty house in an impractical neighborhood, in which I often seemed to be addressing the tasks of daily life by trying to start a fire with two sticks. But now it was a few years later and my heart spun—often on evenings when it was meant to be elsewhere—inside an apartment vestibule above Seventy-Eighth Street, watching itself flash in the mirror, a little Carnevale. Six months before, I had fallen in love with an old friend, an acquaintance, really, a friend of friends, who sometimes had come to dinner with a woman to whom he was or wasn't married, with whom he did or did not live. There was no end to the complications. Soon, a voice said, this will be over: you will not be able to walk on Seventy-Eighth Street. It will be a route on the ghost map of your heart. You will invent circuitous ways to the park, to the subway. You like to pretend that your heart is a top you can spin here and there, wherever you like, but it traces its old routes like a bored child with a pencil! Andiamo, said the voice in my head.

I had begun writing a long letter explaining myself to the man with whom I was inconveniently enamored, who helped me take off my coat when I rang the bell to his apartment at all hours, whose face was like a portrait by Bronzino. Together, then, we characterized our affair as "a hole in the head" (although he is Italian and was brought up in Italy, his mother was an American, and

as a child he had heard the same locutions as I had). The letter, I thought to myself, might be a book. Then an invitation came, serendipitously, to a party in Venice. I decided to go. I would go to the party, and I would write the story. But when it came to it, and the ticket was bought, I panicked.

Everything about it was wrong. I was jittery in fits and starts. I had too much work to do, and I couldn't leave my youngest child; we lived alone now like two cats in the tall drafty house. I had only recently wrested my heart from the long dream: the smiling faces around the table, the family jokes everyone had thought were funny and now were not, because the helium balloon which levitated them and filled them with hectic air had faltered and landed in a grove of spiky trees. *Meow*, said my youngest daughter when we met on the landings. There were other complications. I had stopped speaking to someone I loved, to whom I had spoken most days on the telephone for huge swaths of my life. To someone else who loved me better than I deserved, I had gone on speaking but now said nothing because my heart was elsewhere. I could not go to La Serenissima when I was not serene, when I was afraid of the telephone, of putting two words together in any language.

All winter, I had had a catch in my throat. Once a week, I went downtown to a shabby brick building painted pale green, and talked about panic. Now it was June and uptown, at the house, the honeysuckle straggled up from the garden and in through the dining-room window. Why

was I going to Venice, the city where one is lost at any time of the day, winter or summer? *Una città impossibile e incongruenze?* I had a set to with Bronzino, threatening to leave him because it was the last thing I wanted to do. I began to call a spade a spade. What I wanted was for him to come with me. I sent him the invitation to the party, and he sent a note back: *Un'altra cosa che non possiamo fare insieme.* Another thing we cannot do together. I was unreasonably hurt by this.

The weekend before I went to Venice, I drove up to the country with the eighty-five-year-old mother of a friend, a huge silver poodle, and two little girls, one of them mine. The city was so hot when we left that the girls wanted to try frying eggs on Lexington Avenue. In the car, my friend's mother picked over a newspaper story about the wedding of a granddaughter of a dear friend, recently dead: "Belinda is turning over in her grave," she said. "We are living during the death of privacy." The girls piped up from the back seat, where the poodle was panting under their bare feet. "Was Sophie's grandma called 'Privacy'? Like Prudence, or Hope?" We brought water bottles in the car, but by the time we remembered them, they were as hot as bottles you put between the sheets in winter.

It was cool in the brick house in the evening when we arrived, and in the morning, dew wet the lawn. It was hot by midday, and I sat in a chaise by the pool wearing an ancient two-piece swimsuit, splotched white and brown,

which my children call "the giraffe suit," and fell asleep reading the first pages of *The Ambassadors*, in which Lambert Strether arrives in Paris to disconnect Chad Newsome from the supple clutches of Madame de Vionnet. When I awoke, two hours later, my skin was taut and hot to the touch. The last time I had been sunburned to this extent was on a July day when I was eighteen, fishing for blue marlin in the Chesapeake on a boat that belonged to the uncle of my first college boyfriend, and was laughed at by his mother, a wizened gnome of a woman who smoked Parliaments, spoke French to her children, and had graduated from Radcliffe in 1953. The truth of the matter was that I had planned this sunburn: I knew that after the weekend and before I left for Italy, Bronzino would unbutton my dress and see the burn, and I wanted evidence that I spent time apart from him in which things happened.

Although the time I spent apart from him—which was a great deal, as he was often occupied elsewhere—seemed to me a trance, in which I went about my days as he thought of me, an incoherent, disorderly person given to mad outbursts, wearing odd, expensive clothes, who could not catch her breath. I liked the trance. It suited me, the desolation I hushed as one would a cranky child. Before supper, the girls brought us ices that they had made themselves, with lemonade and mint, which dripped everywhere. Later, I talked for a long time to my friend's mother, drinking gin, until for a minute I cannot recapture it was made clear to me what I should do next.

But, like many things lightheartedly planned by a mad person, the sunburn turned out to be much worse than I had imagined. I was up at night with a fever, which ended with my lying in cool water in the not especially scrubbed bathtub, leaning my forehead against the wall because the porcelain tiles were cool, reading old *Vanity Fair*s and, when they ran out, the first couple chapters of *To Kill a Mockingbird*. I had always liked the description of Scout eating bread and sugar, and learning the alphabet. I liked the idea of being in the care of someone like Calpurnia, who gave you a hiding. That, I thought, was what I needed. The book, a paperback, was so old that it seemed too old to be a paperback; the browning pages came off in tiny pieces, like dried beetle wings. The little girls were sleeping downstairs, and although I thought it over, I knew that through every fault of my own there was no one I could, or should, call to say how sick I was. "What in Sam Hill are you doing?" Scout asks her brother, Jem. What in Sam Hill was I doing?

In maps of the brain, the central cortex is shaped like Venice. The amygdala, the locus of emotion and fear, is the quarter of the church of Santi Giovanni e Paolo; the hippocampus, the site of long- and short-term memory, is the entry into Venice via the Grand Canal; the cerebellum, which regulates balance, the lagoon bordered by the Lido; the hypothalamus, which controls circadian rhythms, the Piazza San Marco. That first summer I came to Venice, I was nineteen. I was with a boy I thought

I might marry, and we sat on the steps of the baroque basilica of Santa Maria della Salute, which is a short walk from where I am writing now, at the Pensione Accademia, in the quieter environs of Dorsoduro. We ate sandwiches made of pressed veal, and drank cans of aranciata. It was too expensive to stay in Venice; we took the train from Padua, where we had gone to see the Giottos in the Scrovegni Chapel, and stayed in a gimcrack boardinghouse where the walls were paperboard painted to look like wood. The ceiling of the chapel was flecked with gold stars. Now, in Padua, you walk into an air-controlled chamber and have fifteen minutes to look at the frescoes. Then, you stayed as long as you liked. We sat in the pews and read letters that Elizabeth Barrett Browning wrote from Italy. It was hot and I argued with the boy—I did not want to hear any more about Savonarola, with whom he had become obsessed. He had written a senior thesis on Jonathan Edwards, about whom I had previously listened. To annoy me, because I would not listen, he was rude to an old friend of mine who had come up for the day from Florence, where she was studying, to meet us.

It has been years since I spoke to either of them. Perhaps it is better for me to come to Venice alone; there is no one with whom I have been to Venice that I am now on speaking terms, as if one caprice of the city is to induce fever dreams from which there is no return. On June 4, 1851, Mrs. Browning wrote to a Miss Mitford:

I have been between heaven and earth since our arrival at Venice. The heaven of it is ineffable. Never had I touched the skirts of so ineffable a place. The beauty of the architecture, the silver trails of water ... nothing is like it, not a second Venice in the world.... But now comes the earth side: Robert, after sharing the ecstasy, grows uncomfortable and nervous, unable to sleep or eat, and poor Wilson, still worse, in a miserable condition of sickness and headaches.

On the earth side, from Bronzino: "Would like to report something amusing yet I have really overstretched myself and am paying for it.... Today high blood pressure, splitting headache, not enough sleep, and all the usual tension." Perhaps my own instinct for complication, for the rococo, for situations that cannot possibly resolve themselves, can be traced to an inability to keep track of a thought a sensible person would heed—a grain of millet blown over San Marco, which, left to fall into the canal, swells and bursts?

The night before I left for Venice, I was beside myself, turning the bedside lamp on and off as if it were a lighthouse, without which I would founder. Beside myself as beside a fish, snagged from the water, slapping its tail on the dock. In the room downtown where I talk about the catch in my throat, the man to whom I am speaking, who has close-cut gray hair and the face of a turtle, who does not take his eyes off me once, says: "Why do we say 'falling in love'? What does it mean?"

In the morning, before I left, in order to distract myself from nervous tension, I walked from the tall drafty house to Eighty-First Street, to buy some books, and then walked back, a round-trip distance of four miles, carrying a new phone I bought in order not to vanish from the earth when the plane touched down at Marco Polo Airport, as if I were a scout going into the woods with only a compass and candy bar, a stick figure teetering on a high bridge. There was a gull on the stoplight at Ninety-Sixth Street. Manhattan is also a city surrounded by water. For months, typing in bed before even the cats woke, the long letter I was writing—the letter that was now shaped like a book, a very bad book, but a book—had threatened to engulf me. I was caught between the present and the past like a fly to flypaper. The past is narrative, Primo Levi says; the present, description.

The best way to approach Venice from the airport is to take the water taxi. It is also the most expensive. Like most things in Venice, there are convolutions before the payoff. There is no transport between the airport proper and the boat dock where the water taxis come in. You pull or carry your luggage down a long pathway, a distance of perhaps a quarter of a mile, following signs put up to encourage the traveler. This is the last direct route in Venice, the last walk on which not to get lost. At the dock, Manolo, the director of water traffic, talks endlessly into his cell phone, gesticulating about what seems to be nothing at all. He is a handsome man, taller than

most Venetians, and indeed, he is not from Venice but from Naples.

The company's logo is a winged gold lion, the symbol of Venice's patron saint, the apostle Mark, who appears to the prophet Ezekiel as a lion with wings; the lion is often depicted over water, to show dominance over the seas. The story of the winged lion is a fairy tale of gilt and chicanery. In the ninth century, three avid Venetians removed the body of Saint Mark from his tomb, in Alexandria. To hide the body, they put it in a basket and covered it with herbs and pork flesh, which Muslims would not touch. As they set sail for Venice, a great storm blew up, and Saint Mark appeared to the captain, who sailed the boat to safety. The Venetians carved the likeness of the winged lion on their doorways, and kept lions as pets. One was kept in a gilded cage, in the piazza, until it died, poisoned by the gilt paint it licked off the bars. A Venetian story. Lions were then forbidden in the city precincts for a hundred years.

After a long wait, water taxis arrive, and passengers board the boats in no discernible order. My suitcase is handed over. The lagoon straightens itself out briefly to a funnel as it passes San Michele, the island of the dead. The boatman knows everyone on the waterway. He raises his hand in greeting to each boat we pass. He is solicitous; if it is too windy I can go in the cabin. It is windy, but I have wound a scarf around my head. He nods, satisfied. We pass through the fog, and then, all at once, it is there: the Grand Canal, beautiful and

absurd. Can there really be gondolas? There are. A little boy waves from the window of a *vaporetto*, a boy who looks exactly like the son who belongs to the face in the mirror. He keeps waving madly, all the way until the taxi turns into the landing of the hotel on the Rio di San Trovaso, right before the Ponte Accademia. For a moment it is all light and water. At the hotel, the hanging geraniums are violet, red, and pink. There is a little step down to the concierge desk, but despite the warning sign I trip.

Everyone trips. The pensione is like the water taxi, like Venice, beautiful and impossible. In the garden, bougainvillea hangs over a glider, a waiter brings you delicious snacks with your evening drink, and at breakfast there is melon the color of a sunset. But you must log on with a different password every day to use the internet, postage is noted carefully in a book, and the windows in your room, though you have asked to have them left open, are shut up tight against the air from the lagoon, which, the chambermaid says, is not healthy for sleep: "Signora, it will give you nightmares." *Incubi.* She makes a strangling gesture with her hands, and rolls her blue eyes like a horror-movie starlet. "You have been here before, yes?" Guido, at the desk, asks, "but with your husband, a man with silver hair?"

In a portrait of the brain made by phrenologists, the cerebral cortex, San Marco, is the location of the sublime. Venice is a city of the unconscious. Joseph Brodsky, who is buried on San Michele, wrote: "I felt I'd stepped into

my own self-portrait in the cold air." And, in the middle of a reverie about the Grand Canal:

> I say this here and now to save the reader disillusionment. I am not a moral man (though I try to keep my conscience in balance) or a sage; I am neither an aesthete nor a philosopher. I am but a nervous man, by circumstance and by my own deeds; but I am observant.... I have no principles; all I've got is nerves. What follows, therefore, has to do with the eye rather than with convictions, including those as to how to run a narrative. One's eye precedes one's pen, and I resolve not to let my pen lie about its position.

What is the position of my pen, writing in the garden of the Pensione Accademia, at ten in the morning in the month of June? Venice is a city of nerves, running on harp strings, Carnevale looping into Lent. My own life, too, it seemed to me, veered between impulse and a mania for privacy and restraint, which is a way of saying that one thing I was especially chary with was the truth. I had many reasons I used to explain this away, none of them good. I slept with the windows open, inviting the incubi. In the middle of the night, a speedboat with the motor idling outside the window, although motorboats after 8 p.m. are forbidden, plays *Electric Ladyland* loud enough to wake the dead on San Michele. Behind the closed shutters, someone in Dorsoduro turns over,

dreaming. A girl walks by on the strada, using her cell phone as a flashlight.

Yesterday, on the way to sit on the steps of Santa Maria della Salute, I window-shopped: velvet, glass, *marzapane* in the shape of starfish. Outside a shop selling evening clutches made of scored velvet, shining like jam studded with gold beads, a woman in tennis shoes says to another, "Very pretty but will you use it in Portsmouth?" The treasures of Venice are like dreams told before breakfast. When they leave the light of La Serenissima they turn to dross. In another shop, I see a tiny glass goblet, azure and gold. The stem is a snake, the letter *s*. In the middle of the night, I resolve to return to the shop and find it again—a present for Bronzino. The laptop on which I am typing here in the garden keeps New York time: it is 4:27 a.m. in the tall drafty house and on Seventy-Eighth Street, which is empty because he is sleeping elsewhere. I am awake while almost everyone else is asleep, although an email arrives sent from Christchurch, New Zealand, dated tomorrow, from the voice on the telephone to whom I am not speaking. It does not tell me what to do next.

I have been in many cities on my own before, but not Venice. I write to Bronzino, but for now do not send a message that says, *I very much wanted you to come with me but now I think it is better you did not*. I say I will explain when I return. At a concert at San Vidal, at the turn of the Accademia bridge, I list all the reasons I must embark on my own into the byways of the lagoon. One: Bronzino

understands music deeply, I do not. The first half of the program is Vivaldi, and I resolve to leave at intermission. The church is full of students, it is hot, I am thirsty. Instead, I exit in the interval and buy an aranciata at a bar in the campo, then find myself back in my seat. It is Corelli's Concerto Grosso in G minor, and I burst into tears, although I do not know why it moves me or when I have heard it last.

The next morning, at Santa Maria dei Miracoli, hemmed so tight in Cannaregio that it might be a white handkerchief in the district's pocket, I am in tears again. The confectionary marble church, finished in 1490, was built to house Niccolò di Pietro's icon of the Madonna, which is said to have shed real tears. Perfectly restored, the church is a favorite of Venetian brides. Mermaids and angels are carved into the chancel. When I first saw it, at nineteen, I thought: I will get married here. I have been married twice, neither time in Venice. It is perhaps not adequate to say that the marriages have not lasted, for, after all, they have yielded children, monographs, candlesticks, cabinets, all of which are scattered here and there, lasting.

On the way to the campo, I find a shop where years ago I bought a gold bracelet that I later lost in New York at the movies. The proprietor, older, is seated in exactly the same place, behind the glass counter filled with junk. Is there another bracelet? No. She shows me an extraordinarily ugly opal ring, which I consider buying. The last time I was there, on the steps by the shop was a little girl

just out of her pram, with whom I shared a cornetto, while her parents drank *un'ombra* across the campo, looking at me gratefully. I was married then, and my husband sat nearby at a little table, drinking a coffee. In his pocket was a box containing gold earrings set with jade and pearls he had found while out walking that morning. It was the last trip we made together.

In Venice there are the usual places to go: San Marco; the Frari, where the Madonna soars convincingly up to heaven; the Rialto. These places do not usually include the church of I Gesuiti, on the esplanade of the Fondamente Nove. The way there is along the west flank of the hospital, near the Questura. I ask a young mother pushing a baby, who holds a sticky ice cream, for directions. The sun is so hot that I inch along, looking for shade. Then there is the high arched bridge beyond the vaporetto stands, and the Gesuiti, looming, solemn as an elephant. The first time I came here I was sick, and the sacristan found me a place in the back where there was cool water and I could put my face in my hands. Today heat gleams on the steps. Inside it is quiet. I am the only person on earth in the church. How can it be? The floor, which is made of black-and-white marble, a geometric pattern not quite classifiable, is uneven and undulates beneath the pews. The interior is entirely black and white—Jesuitical. When I look up I am amazed to find that the curtains over the pulpit, which I had always thought were huge swags of black-and-white figured velvet, are in fact marble carved to look like velvet.

In Venice things are and are not what they seem, the strobe light of the imagination is on full-time. It is daunting, the combination of beauty and legerdemain. On the way back to the pensione, after an evening out, the water under the Ponte Accademia is black, then azure, the lights of the vaporetto turning the waves sunset colors until it disappears in the direction of Ca' Rezzonico, the palazzo where Robert Browning died. It was owned by his son, Pen, and his rich American daughter-in law, Fannie Coddington Barrett; Browning, whom Venice made nervous but who could not stay away.

I carry souvenirs in my pocket, places to find. Today, it is a restaurant, La Colonna, near the Gesuiti, where years ago my husband and I ate *spaghetti alle vongole,* and admired the drawings by the proprietor's children, thumbtacked to the walls. A shop near the restaurant sold very old Murano glass, of the kind you cannot find in the arcades filled with junk near the Rialto and San Marco. But where is the shop? On the map, it is near something called Calle del Fumo, but the Calle del Fumo does not continue to the Fondamente Nove; it issues from a cul-de-sac that seems to have no entry point. There is no phrase in Italian for "as the crow flies." In Venice, it is easy to start in one place and end up completely lost very close to where one started. My map is too big and detailed. I can find nothing on it. I stand still on a tiny bridge, bewildered. You are *here*, a woman hurrying with a briefcase shows me, an emerald ring on her finger that points to a tiny, inconclusive triangle.

When the children were little we told them, if you are lost, stand still in one place and do not move. Rose, at eight, in the butterfly house at the zoo, stood stock-still, a tiara of butterflies encircling her head, hands stretched wide, bright wings opening and shutting on her arms and legs.

The beggars in Venice are unlike beggars elsewhere, kneeling on the pavement for hours, marking a spot, not moving. In a scrap of shade in Campo Santa Maria Formosa, one woman sits all day, a shawl over her head, immobile, saying nothing, a mute question mark lowing to a handful of coins. Each day, on the way to Santa Maria della Salute, I pass a blind woman, crouching. At the end of the overpass a cellist plays "My Way" until it curls around the piazza like smoke. Yesterday, on the bridge on the Riva degli Schiavoni, near the Danieli, there was a beggar I had not seen before, a woman with what looked like fur covering half her face. An apparition. Legend says that Venetians are half beast, half human, but it was the first time I had seen evidence of it. If the Venetians are Ovidian, I would imagine that they are half fish. The palazzi along the Grand Canal resemble most closely the illustrations in a book of fairy tales I had when I was a child—the palaces of Neptune and his regiments, the mermen.

The Biennale is going on. Banners disfigure the palazzi with slogans promoting exhibits that are meant to be evocative—notes handed to a pauper in a fairy tale, "The Dream Whisper," "This Is Not a Pavilion"—but like many things in Venice they are absurd. It is the question

of apotheosis. It is hopeless to show new art in Venice. Nothing can rival what is there. But one reason to go to the Biennale is to visit palazzi that are often closed to the public. One is the Palazzo Zenobio, named for a woman who married Septimius Odaenathus, the king of Palmyra. He died, and within five years, she had invaded and conquered Anatolia. Captured by Emperor Aurelian, in AD 274, Zenobia is said to have been exhibited in a cage in a victory procession in Rome. It is unclear whether she, too, licked the paint off the bars. This time, a happy ending. On account of her "military acumen and beauty," perhaps not in that order, Aurelian freed her and presented her with a villa in Tivoli. Her descendants include Saint Zenobius, a fifth-century priest of Florence.

The Palazzo Zenobio is behind the Campo Santa Margherita, beyond Santa Maria del Carmelo, the church dedicated to the Carmelites and the mystery of the scapular. Today it is hot and the church looks cool, and I go in. In New York it is raining. Two marble staircases mount to the second floor, where in one corner there is a painting representing harried Prudence, who holds a mirror pointed to the sun. A serpent has coiled itself around her waist. I am struggling to read the Italian—this Prudence is of two minds, to be prudent she must first admit temptation. Is that it?

Beyond the campo the deserted calle ends at the Palazzo Zenobio and a lawn overgrown with weeds. A cooking fire has left char marks on the grass. One wing houses the Armenian Pavilion, which shows a slow-running

video in which a person playing Lenin appears. On an explanatory placard, the curator has written, "loss of relevance of a future at one stage of life, leaving creative residue." The letters curl around my neck, a noose or Prudence's serpent, biting its own tail. But the palazzo's own stupendous hall of mirrors confounds, a gallery of reflections, each twenty feet tall, as if they held the gaze of all the people who have looked into the wavy glass, hoping to find the spirit level.

I had come to Venice to attend a party. When the invitation, heavy and cream-colored, first arrived, it felt like a sign, especially for a person who spends an untoward amount of time reading tea leaves. The party was in honor of the Joseph Brodsky Foundation, which brings young Russian writers to Italy. When Brodsky's wife, Maria, and I were young, we used to sit on the Brooklyn Promenade, steps from the Brodskys' house on Pierrepont Street, and show our baby daughters the boats passing by on the East River. I had known Joseph before he met Maria; by then we were old friends, and Maria and I became new mothers together. He died in 1996, when I was living in a ramshackle apartment near Columbia—I heard the news on the radio, and borrowed twenty-five dollars from an upstairs neighbor, thrust the baby into her arms, and took a town car to Pierrepont Street, where Joseph lay upstairs in his study, arms folded across his chest.

Early in the morning of the day of the party it rained, and the air that came through the open hotel window

was thick. But by the afternoon the sky was a clear enameled blue. When my daughters were growing up in the tall and drafty house, they spent many frenzied hours dressing for parties to which they decided at the last minute not to go, or for which they left long after I had gone to bed. During these dressing-up sessions they complained constantly that the house had no mirrors—or that there were mirrors but you could only see yourself from the waist up, or that the lighting was bad. Venice is in love with its own reflection—mirrors are fixed into the walls of the city.

By three o'clock, in my hotel room, I had dressed and undressed myself several times, gazing into a flecked full-length mirror by the wardrobe. What did I expect to see? I had brought two dresses: one made of tiers of black chiffon, and the other a sleeveless frock with a plunging V-neck and horizontal stripes of dark green, wine, and silver, which looked now to me like an eccentric Christmas ornament. But in the black dress I looked like a raven. In the middle of this unhappy revelation, my phone, lost in a heap of clothes on the bed, buzzed. A message from Bronzino. *It is evening and raining in New York. You are very close.* This message sent me into a rage. I was not close, I was far. I had wanted him to come, he had not. I was half dressed, looking like a plucked raven. In New York, a few weeks before I left, I was dressing to go to a party at which we had arranged to meet, and he had texted, *Stop fussing and get in a cab.* I felt a longing so severe that it was as if I had been pierced by the twin

swords of the Tarot pack, the blades of indecision and despair. What in Sam Hill was I doing?

Friends had arrived the night before to attend the party. One, a poet who came from London and had not been to Venice before, looked bedazzled. Another was a poet from Des Moines who was once married to my childhood best friend's college roommate, a high-strung girl with whom he argued constantly, and who wore short black leather skirts and so much kohl that it looked as though she had black eyes, which added to the atmosphere of violence that surrounded them. A third friend wears her blonde hair coiled on her head like a Dutch maiden, and will tell me later that night, as we are walking, somewhat drunkenly, toward San Marco, "Venice is too much for me." The three of them have come to the hotel and we will go to the party together. They are drinking Aperol in the garden when I appear at four thirty, in my Christmas ornament dress, a small safety pin holding the plunging V-neck decently closed, over which I have put a mustard-yellow coat. I am wearing one pair of shoes and carrying another, as even I am not so mad as to think that I can negotiate a walk through Cannaregio in high heels.

From the Accademia stop, we take the vaporetto to the church of the Madonna dell'Orto, the parish church of Tintoretto, where his ashes are interred. Beside it is the Cappella dell'Orto, where the party will be held. The chapel has been in private hands since Napoleon invaded Venice and sold off the church's holdings—a moment of

high commerce in a city in which beauty is wed to ava-
rice, a hunger of the eye—and is now owned by a Venetian
contessa who, like a character in a Henry James novel, is
married to a man from Connecticut named Mr. Atwater.
When we arrive, the huge door to the chapel's cloister is
shut; we pull a cord and a bell sounds, and a young man
in an open-neck white shirt and black pants lets us in.
While outside the sky was a deep blue, here it seems
softer, as if heaven were casting a more benign eye. About
sixty people are milling around, their faces like those
who might have stared back from the mirrors at the Pa-
lazzo Zenobio five hundred years ago. Here are the high
brows, wide mouths, the steady gaze as painted by Bellini.
Away from the sight of water, they seem to blink.

The women do not look as if they had fussed in front
of a mirror but as if they had been born to their clothes:
beautifully cut linen skirts, in pale colors, as it is summer—
mauve or peach, the shades of a Murano chandelier;
white silk blouses; low-heeled handmade shoes with
tortoiseshell buckles. At their ears, they wear large em-
eralds or rubies, and around their necks are chokers set
with natural pearls, the size of knuckles, with sapphire
clasps. These are old stones. Their hair is gray or streaked
with silver, pulled into chignons. Their daughters are in
floor-length chiffon dresses, pink and amethyst. In the
cloister, as the Venetians talk to one another, with the
ease of ancient familiarity, I feel I am in a different Ven-
ice, where extreme beauty is in itself legerdemain, a dis-
traction from the city's guarded inner life, which balks

at intimacy; the unattainable mystery of the calle that goes nowhere except to another quay of lapping water.

Is this the city's attraction? A ruby catches the sun and shoots tiny red lights onto the columns, near where waiters are setting down large woven baskets of what look like pieces of soap. There are ten rows of gilt chairs facing a podium. Soon we take our seats—there is an American painter I had met the previous day, with his Venetian wife, whose long blonde hair is pressed to a sheen. In front of me is a young couple who live near Ca' d'Oro, in an apartment in a palazzo that belongs to his great aunt; she is from Madras, and wears a violet-and-turquoise sari, gold bangles covering her slim arms. She gives me her card, which is printed with a dragonfly, and we arrange to meet for drinks the next day.

From the podium, there are introductions and explanations and then a reading of Joseph's poems, in Russian, Italian, and English. Behind the chairs, three children chase a ball. They are dressed in white, like children in a Sargent portrait. The pieces of soap turn out to be Parmigiano-Reggiano, salty, sublime. The waiters pass around glasses of rosé and little sandwiches of cucumber and caviar. By now, the safety pin has been lost, the Christmas ornament dress is gaping, the children are bedraggled and arguing over the ball, one of the girls has torn her pink sash, and a gull rises up from the cloister with the end of it in its mouth. The American painter shows me postcards of his work—watercolors of Venice, all of them almost exactly the same, like a pack of

playing cards. The next day, when I dial the number on the card with the dragonfly, it has been disconnected.

After the party we have supper in Cannaregio, where we are fed fish and spaghetti and limoncello, by a waiter named Tony, who magically found a table for a dozen people. From there we go like pigeons to Piazza San Marco, where the clock, which also shows the dominant sign of the zodiac and the phases of the moon, says midnight, and the gold horses are ghostly above the tesserae. Florian's has just closed, but we sit down anyway. The beauty is almost too great to bear. The piazza is almost empty. It was time to go. We have all known each other a long time. Someone says—the English poet brought up on Greek, at the end of his first day in Venice—looking at the gone light that held the living and the dead, "It is impossible to get over this." I look at him in the half light and wish it were true.

It wasn't until noon the next day that we got going: a group outing, discussed the night before, to San Michele to visit Joseph's grave had whittled itself down to two— Bill, a New York poet, and me. The plan was to meet at his hotel, the Palazzo Abadessa in Cannaregio. When I arrived on the water taxi and passed San Michele, I thought: this time. I had not gone to Joseph's burial on the island; at the time I had been deep in a life of small children, and the idea of riding a gondola to the island of the dead half the world away seemed not only unmanageable but ridiculous, like wearing fancy dress for breakfast. But, now

that I had veered from that life into another, I regretted that impulse toward practicality, which in its various manifestations had not only gotten me nowhere but had imploded, leaving a kind of wreckage. It would have been better if I had gone.

I left Dorsoduro late. The vaporetto kiosk took twenty euros and then refused to spit out a card. The vendor behind the window shrugged. So I paid again, a donation to the coffers of Venice. At the Ca' d'Oro stop, ejected into the Strada Nova, which presumably led to the hotel, you might be on Elmhurst Avenue in Queens but for the fourteenth-century facades and the boys on Vespas. Bill's directions include a jog on the Calle de le Vele, but the pavement ends inexplicably in a backwater. I ask for the hotel and find out it is right there, three paces away. "You mean," says the accommodating old man who looks at my map, "on the way to Santa Maria della Salute, the *other* Calle de le Vele?" From Bill's hotel, we walk to take the vaporetto to San Michele.

The trip took five minutes. When I had imagined it, it was a long trip over the water to the land of the dead, but instead it is sudden and short. The boat shoots through the waves—it is rough in the lagoon today, the sky has the yellow pallor of a storm coming—and the landing comes up before we have had a chance to look back at the glittering city. The vaporetto stop is Cimitero. At once it is hot and still. A man is there with a paper map. Unusually, for Venice, a city of lucre, the map is free. The space on San Michele is so limited that Venetians are

allowed to rest here for only ten years, then they are transported to an ossuary off the island. The only bones that are allowed to remain are those of the foreigners in the Protestant cemetery. We amble, fetching up at different graves: Alice Harris Hare, citizen of Venice; Captain Alexander Woolsley, captain of the *Minerva*, "taken on board," whose epitaph is "The heart knows its own bitterness and the stranger meddleth not." An iron cross reads, "Auf wiedersehen."

We cannot find Joseph. We are deciding between being vexed and being amused by this. To give ourselves time to decide, we walk in the Greek cemetery to find Stravinsky, who is buried next to his wife, Vera. Little lizards whisk over the stones. There is a spray of white roses on his grave. Diaghilev is to the right. His monument is a miniature theater; on the plinth there are old toe shoes left by dancers, stained by the weather. There is a particular kind of artificial flower on many of the graves, with petals made to look like antique, burnished roses, pink and gold. It is as if the imagination is stuck: everything is gilded, mossy, seventeenth-century. Most of the graves are in disrepair. Crosses have fallen over, the cold has heaved open some of the stones, as if the dead are rising out of the earth.

We make another try at the Protestant cemetery. Bill takes one turn, I take another, walking widdershins, and find the grave almost immediately. I call Bill. The sound of his name, frittered over the clogged earth, is unseemly. We had missed it because it is completely covered by

cabbage-rose bushes in full bloom. The roses are salmon-colored. Rusty hellebores skirt the base. *Letum non omnia finit.* It is the first grave of someone whose body was known to me by touch long ago in the dark, the beginning of love. He liked to play chess after having supper at an Indian restaurant around the corner from his flat on Morton Street. My grandfather had taught me, but I was a terrible player. "Call me when you get home," Joseph would say, when I left late at night to take the subway uptown. Bill and I place stones on the grave. They make a home alongside a little collection of others. We return to the vaporetto. In an instant, we are back on the Fondamente Nove, the vaporetto tossing like a toy boat in the waves. Bill is going to the Lido, which he has always wanted to see. I am going back to the Madonna dell'Orto, on my own, to see the Tintorettos. The night before there had not been time.

It looks easy on the map, the way from the vaporetto stop to the Madonna dell'Orto—a straight walk down on the Calle Priuli to the Strada Nova, then back up to the Fondamente Nove. The expression that comes closest to "as the crow flies" in Italian or Veneziano is *linea di'aria*. (Months later, Bronzino will insist that *crow* is *corvo*, but it is also *raven*, or *ucello nero*, although the raven is *corvo imperial*. And why, he asks, would a crow fly in a straight line? "Have you ever seen a bird fly in a straight line?") I do not want to go all the way back to the Strada—there must be a shortcut. There isn't. Every calle is called Calle di Mori. It is a dream landscape by

de Chirico. There is no one about but a bearded vagrant who follows me, giving directions to the Piazzale Roma. He is vaguely menacing, but seems soft in the head. When he deserts me, he devolves on a man engrossed in fixing a motor by the bridge; dirty pieces of it lay scattered on pages of *La Stampa,* which he has carefully put down to protect the stones.

Suddenly there is a busy calle by a canal. A waiter feigns ignorance, until he is shown a map: "Ah, signora, the Madonna dell'Orto—turn left at the bar with the red awning. Then it is there." A few people are milling around the oblong piazza. A sign on the door states that this is a lucky day, *una giornata fortunata,* the church is unexpectedly open, giving a visitor the opportunity to make a monetary contribution. The door to the cloister is bolted shut. In the church, I am given a plastic guide in Italian. I am tired, and I ask for the English version. The girl has a mass of black curls. The word for black hair is *corvino*: raven-black. Yes, milady, she replies, her English, like the church, seventeenth-century.

The guide is clear and even nuanced. To the right of the nave is the tomb of Tintoretto himself, but the draw is the altarpiece, the dark twister of Tintoretto's enormous *Last Judgment.* Does anyone get to heaven? Caryatid angels hold up the soiled robes of vengeful Jehovah, everything and everybody is blown away. But the painting is so impersonal, so total in its scooping up of the wronged and the sorry, that the result is to feel relieved. There is nothing you can do to prevent it; we are sinners

from the start in the hand of an angry God. And ready to be consoled by the annunciation at the altar, in which the wings of Tintoretto's angel are made of shadow. To the right, above it, Prudence again, tormented by a snake while she holds a mirror. *Vide e crede*: we invent our own punishments. On the west aisle is Titian's *Tobias and the Angel*, in which Tobias's open mouth exactly mirrors that of the angel, as if they were speaking in tongues to each other in a language we can just hear. The church is full of wings and water. The angels might be great birds, egrets or white herons, moving the damp air, the air of the incubi, with their feathers.

It takes only a little time to walk back to the Strada Nova and the vaporetto at San Marcuola. The vaporetto tonight is almost empty and seems particularly slow, as if there are stops along the Grand Canal that have materialized in the dusk. But no, it is the same—San Stae, Ca' d'Oro, San Silvestre. I get a seat in the stern, next to a little girl wearing a pink fairy costume. Her slippers are jeweled and she is carrying a pink-and-silver wand. Some of the palazzi are being restored; they are wrapped in gauze, like spun-sugar chrysalises, or like the tents erected by the Venetians in honor of the visit of King Henry of France, in 1574. The Biennale banners continue their inane chatter over the water: "A Remote Whisper," "Formal Feelings," "Gestural Anatomy," "Otherwise Occupied"—the last at the Palestinian Pavilion. I get off at Accademia. At the foot of the bridge is another little girl, with her grandfather. They are there all day, every day. He

is the proprietor of the newsstand. When she is tired she sleeps in a red wagon by his side, which he has outfitted with a blanket. Tonight she is eating a slice of Venetian torrone, almond paste embalmed in sugar dyed bright pink. The sun is swooning on the windows of Browning's Ca' Rezzonico, and reflecting on an open window above a box of trailing gentian on Rio di San Trovaso.

New posters have been pasted on the walls during the night: *Go as Far as Is Possible*, a performance at Ca' Foscari, a week from now. People walk dogs over the bridge. The favorites are Jack Russell terriers, often in pairs, walked by women wearing a ransom's worth of gold jewelry. The other day a huge Saint Bernard came out of nowhere from a dark calle into Campo San Barnaba, walked by a boy of about fourteen wearing a Yankees cap. The first time I came to Venice cats were everywhere, sinuous, skulking in corners. Bowls of spaghetti were put out for them next to the trattorias, and a dozen would gather around them, their tails like spokes of a wheel. Where are they? According to Maria, whose nickname is Kitty, all the cats were castrated by decree. Can this be possible? In any case, she is in a lather—"They kill the cats, and end up with rats!"

In the evening it rains. For a while it is possible to sit outside in the hotel garden reading, under the umbrella, but the wind comes up. I sit in the upstairs loggia instead. The long green shades have been shut against the downpour. Only one lamp is lit, and I cannot find the switch

to turn on the huge Murano chandelier. The hotel is fanatic about electricity. The lights only come on if you hang your key on a hook; otherwise, they turn off automatically in thirty seconds. I go back to my room to change. The battle with the chambermaid continues; the windows are latched and the shutters are shut tight. The room is airless as a tomb. I fling the shutters open so quickly that the curtains get caught in the latch mechanism, and damp air floods in, smelling of moss and debris and mint from the garden.

Later I take myself to dinner on the Zattere carrying an umbrella. But the rain has stopped. It is a restaurant where I once sat in Wellington boots, as the tide—the acqua alta—surged over the embankment. The buffalo mozzarella is a little cloud, and with it I drink cloudy prosecco. The woman at the next table is from Alaska; she is describing Anchorage to the owner, Giuseppe, and he is shaking his head in wonder. A gigantic cruise ship, seven stories high, looms in the window. The couple at the next table have just gotten off such a boat: it was terrible, she says, in German. "Die Leute!" She shakes her head in consternation. She is glad to be on dry land, she says. It is improbable, to think of Venice as dry land, this city of water. I walk back along the Zattere and feel the soft wind moving through me as if I, too, suddenly weightless, were an apparition the city has dreamed.

I had written to Bronzino about I Gesuiti and Santa Maria dei Miracoli. A note comes back.

You must tell me why you were in tears. As you know, it is one of the finest Renaissance churches in Italy. Of course, the Gesuiti is an entirely different 17th century idea of sacred space. In Venice one is a stone thrown in the water, yes, perhaps more so in Venice, but isn't this true of anyplace we find ourselves on this planet. The dead in San Michele, the dead in ourselves?

I had come to Venice because I was preparing to break my own heart and I needed another version of love. We invent, with careful attention to detail, our own punishments. *I do not know*, Bronzino wrote, *why you say it was better that I did not come. You will explain it to me.* It was better that you did not come because in Venice I made up my mind that I would have to do without you. Because you did not come, because my heart is not as elastic as I had thought, or hoped it would be. Because I had fallen in love. Because Prudence told me to leave. In Venice, Joseph wrote, "It is possible to proceed on nerves."

Chess is a careful game. It is useful not to lose the queen, who has the largest range of motion. Prudence holds a mirror and her belt is a snake. My eyes preceded my pen. I was looking for her but I did not know it. In the morning I packed my bags. The water taxi had been called but I had come downstairs early and walked to Campo Santa Margherita and ordered a cappuccino at Caffè Russo. There was the woman endlessly mending the blanket. A man read *La Repubblica*. Two women drank

grappa. I walked back to the pensione past the Osteria ai Artisti and the place where I had bought the goblet with the S-shaped stem, and waited for the taxi. A text from Bronzino. *It is time to come home, yes?* I crushed a sprig of mint in my pocket, and saw my first cat edging along the canal, his fur on end.

Roma

To begin where she left off.

Elizabeth Bowen, the Anglo-Irish writer, arrived in Rome, for a stay of three months, in 1953 at the Hotel d'Inghilterra on the Via Bocca di Leone, near the Spanish Steps. She had too much luggage for the plane, so she has taken the train from Paris. She arrived at night. From what she can see, led to her room along a series of dim corridors, the hotel is "estimable and distinguished, nothing gimcrack." The room is crowded. An armoire, a marble-topped table. The lampshade is painted with a picture of the Campidoglio. Too much time in a small space? she asks herself. She is shy to complain, but in the morning, it takes one word, and she switches to a more satisfactory room, on another floor. She has been married for twenty-five years, to a British civil servant, Alan Cameron, but for the past six years she has been in love with a Canadian journalist, Charles Ritchie. The affair will last another thirty years. When she dies, he will write, "If she ever thought she loved me more than I did her, she is revenged." She did think so. Her novels take as their subject how things, big and small, go awry. In *The Death of the Heart*, a masterpiece of concision, she asks, "Who is ever adequate? We all create situations each other can't live up to, then break our hearts at them because they don't." From Rome she writes to Ritchie, "Every day, at all times and places I think of you." A month into her stay, "I am walking Rome like a maniac. Not at random, I work out a route every day." She buys street maps, folding and unfolding them until they tatter. She

discovers, as does anyone who spends any time in Rome, that curiosity is a form of courtesy. What is she doing in Rome? Writing something? She is warned that writing about Rome makes one "rhetorical," "platitudinous," "polysyllabic," "furious." The city, she thinks, is masculine. (Venice is feminine.) At dusk she walks on the Palatine. Like those who by habit or folly or circumstance allow themselves to be rent in two by the city, she finds herself *of* rather than *in* Rome, subject to its vicissitudes, its centrifugal pull. Rome is like a great railway station, in which the past and the present are coming and going. On leaving after three months' time, she wonders whether the charged goodbyes, to streets and to basilicas, are ignited by something she carries with her wherever she goes, rather than by the places themselves. Does love settle on the mortal, rather than on the immortal? On the train, as she looks out the window, the houses seem to turn their backs. Tears sting her eyes. Her account of her time in Rome ends with the coda of impossible love, a ribbon of skywriting, "My darling, my darling, here we have no abiding city." But what is love and who is we? And where? For if all roads lead to Rome, they begin there, too.

More than half a century later, in London, on a Sunday morning, I take a taxi down Regent Street, with my battered, too-heavy suitcase. It's raining. I am about to make my third trip to Rome in six months, one from New York, at Christmas, and two from London; the first in April, overnight, and this trip, in June. Like Bowen, I was

making anything but a clean start; as she says, "Simply coming to Rome cannot be half so complex as coming back." The driver follows the 170 bus route through Pimlico, past the Chelsea Physic Garden, and Battersea, and I suppress the impulse to tap on the screen and ask him to stop, I will stay in London. At Gatwick, the flight is delayed two hours. A man in a leather jacket is speaking into his phone in Italian, while a younger woman—his wife, his daughter? impossible to tell—also in leather, wearing precariously high-heeled sandals, eats chips out of a bag, one at a time. The departure time continues to update on the monitor while I am distracted by a telephone call to New York—a dilemma for which I should be home. Finally, the gate is posted; of course, it's on the other side of the airport.

I am so exhausted that I fall asleep on the plane, but not before thinking: why do I keep returning to Rome, when there are so many other places to go? A kind of obsession, that finds its course, like a marble wobbling down a gyroscope, to a city founded by a boy suckled by a wolf. Just five weeks before, the overnight trip had been to attend a concert at the Parco della Musica. Then, on my way out of the city, the taxi took me almost all the way to Ciampino Airport on the Appia Antica, the long road of memory, like a green seam, and although I knew I was coming back soon, I was in tears, as if I were being wrenched from a beloved—what? A place? A child? On the Arch of Septimius Severus, at the northwest end of the Forum, a Parthian, in a triangular helmet and knee

breeches, is being led to prison by a Roman soldier, but his gaze is reserved for the infant in his arms. A record of tenderness. Or, as usual, do I read into it, turning a complicated story into a lullaby? A week from now, when a friend comes to visit, he will chide me for the tears that come to my eyes, and say, "Remember, this was hell disguised as heaven."

I have with me, as I do every trip to Rome, my old copy of Liddell's *History of Rome*, with a gold wolf embossed on the worn cover. Like any tale told in or about Rome, the story of Romulus and Remus veers like a crow over a catacomb, tracing hieroglyphs in increasingly smaller circles, until it zeroes in on its prey, so quickly it's hard to see what happened. Or a painted fan of the constellations that closes as quickly as it opens, before you can sketch even the faintest bright outlines of a story that left its afterimage on the dark sky. The story begins with two brothers, Amulius and Numitor, last in line of the eleven kings of Alba. Numitor, the elder son, had no interest in the crown, and gave it to his brother. In return for his generosity, Amulius had Numitor's son put to death, and his daughter, Rhea, dedicated as a vestal virgin. But the god Mars pursued Rhea, who gave birth to twins. Two boys, Romulus and Remus. Her punishment was to be buried alive; the children were thrown into the Tiber, where they came ashore on a shoal in shallow water.

As Liddell writes, "Destiny is stronger than the will of man." The twins are suckled by a wolf, fed by woodpeckers, found by herdsmen. Their parentage is revealed. But

which is the elder? Whoever sees a flock of birds at dusk will build the city. Remus sees six, Romulus twelve. Or is it the other way around? Did Romulus slay Remus, or was it his friend, Celer? Like all Roman stories, or most, this one tells of a city built on portents and omens, seen through centuries of dreams. Among the lost legal documents of Rome, the Lex Cornelia and the Twelve Tables, one of the only things that has survived is a law concerning justice against enchantment, the power of the *malum carmen*: "A song or rhythmic formula that produces a negative effect on something." Or someone. Impossible to say exactly what. But ambiguity, as Ovid teaches us, is power. To try to pin anything down is itself hopeless, to the very nails. In ancient Rome, a nail in a henhouse protects against thunderstorms, a nail at the place of an epileptic fit pins the illness to the ground, a nail put in a coffin protects the soul from malevolence. Decades ago, on a visit to cells underneath the Vatican, I watched an old woman in black put a nail on the tomb of a pope dead almost nine hundred years. When Athena's owl dips its left wing, it means, "Birds can die of jealousy, and the owl could not care less." An owl feather placed next to someone sleeping will make them speak and reveal secrets.

We descend through a cloud bank. I know that when I arrive in Rome I will be full of plans to go one place or another, somewhere I've never been, and as usual, I will go nowhere, like a somnambulist who simply walks around the room without leaving, like the taxis that, no matter where you are going, circle the center of Rome, at

the Piazza Venezia, once, sometimes twice, for good mea-
sure, before taking you to your destination. After London,
the night is hot and thick. "Is it raining in London?" the
taxi driver asks. He sighs with longing when I say yes. At
nine in the evening, the road is deserted, as if traffic to
the city has been suspended. As we sail down the auto-
strada, my blood sings as always at the signs for Roma,
as if each time feels a lucky discovery, as if I were return-
ing, although I have lived elsewhere all my life, from a
skirmish with elsewhere, narrowly averted. This makes
no sense to me, nor to anyone who knows me. "You
would be bored to death in six months if you lived here,"
my Roman friend Massimo says. The taxi passes through
the Porta San Giovanni, the huge arch like a giant's raised
eyebrow, as if to say, You! Again?

But, for once, the taxi doesn't loop down to the Piazza
Venezia but up the Via Nazionale. The streets are crowded
near the tobacco shops, and people sit outside the cafés.
It's dinnertime in Rome. The air smells of trash and salt
and, at this time of year, honeysuckle—to me, the scent
of Rome. In the dark, the apartment number of a friend—
or, more correctly, the cousin of a friend—with whom
I'm spending the first night in Rome, eludes me. For
a moment, I have the solo traveler's feeling—a false
bravado—of abandonment, a changeling on the door-
step, that I combat by thinking, Well, if she isn't there,
I'll go to a hotel! I try calling her from the taxi and, on the
third try, she answers. "It's the bell on the left!" But there
is no bell on the left, only on the right. An arm appears,

waving from a window two stories up, and then her close-cropped gray-haired head. I hear her call, "Ecco!"

Once inside, I recognize the vast marble hallway and the tiny iron lift. In the apartment, the gates in front of the beautiful tall windows are locked—at Christmas, there was a burglary. We open them and step out onto the terrace for a moment. The lit-up, dilapidated wedding cake of the Colosseum is almost close enough to touch. A table inside is set with couscous, a platter of bresaola, and a Parma cheese, soft as ricotta curds, soaked in *vin santo*. The taste is of yeast and decay. I present my offering: stem ginger biscuits bought early that morning, in London, on the way to the airport, after a weekend when I pretended not to know whether to go or to stay, and thinking as usual that it made a difference. Though, as I was told once long ago, as I peered at a map, on a restaurant tablecloth in another city, "We know now, if you think we should go one way, it's the other!" Except in this city, where from the first I have felt, if not at home, my coordinates exactly.

But this is the first trip in years when I have not been accompanied by someone, though the person who used to come with me never, not once, became that ordinary person, a traveling companion, preferring to look on from afar, to set treasure hunts, to send messages. Now he has become a ghost, *lo spettro*, printing himself like a drowned negative on the walls of this city where he lived with others—in a spaghetti factory, in an apartment looking over the Vatican, in Monti, or near the Villa Ada—

but never with me. But as Liddell says about Rome, the importance of stories does not depend on their truth as history.

We eat the Parma cheese, which tastes of mold and elderflower, with the English biscuits, which are homely and sweet. Two old conspirators, we smile at each other. When we were together here two years ago, all I could talk about was the ghost. Now she asks, "Cosa mai gli è accaduto?" Whatever happened to him? "Basta," I say. She is a psychoanalyst. Then, in English, she tells me, "I was very harsh with you. I regretted it." "You were exactly right," I say. She shrugs, then, "But, as I said, a textbook example of a *narcisista.* And now?" I can shrug, too. "We'll see." From a bookcase in the sitting room, she pulls down a memoir by a former patient and reads aloud, translating for me: "He was only elusive when she wanted him to come near." But where does that leave us? For years, wherever I have gone, you have come with me.

The next day, I moved to a studio apartment on the top floor of a house above Trastevere, the old bohemian quarter of Rome, a climb up the terraced hill above the city's largest fountain, the Fontana dell'Acqua Paola, which this summer is boarded up for repairs. Inside the heavy gate, in stone urns on the stoop, pale pink parasols of ivy geranium are wilting in the heat. Inside the marble entryway, it is cool as an aquarium. In Rome, where there is almost no air-conditioning, there is this: the effect is like leaping into a lake lined with stone. Underfoot, even in the simplest foyer, there are terrazzo tiles, labo-

buy overpriced bags of dried porcini or pasta in the colors of the Italian flag, here the market is silent but for an almost soundless patter of "piu, piu, piu?"—more, more, more? The fruit man asks me, "More plums? Or more strawberries, just new today?" But I know they will not last more than a day in my room, warm under the roof.

As nothing lasts. Or does it? There comes a point when one realizes that almost everything in Rome has been recycled, reused, remodeled. A few hours later, having deposited my shopping under the eaves and walked down into Trastevere, I cross the river and find myself at Largo di Torre Argentina, leaning over the parapet for the hundredth time to catch sight of the street cats sunning themselves on the stones of the four Roman temples that once stood here, named A, B, C, and D, like scattered building blocks. I scan the wreckage for some sign of the place in the Theatre of Pompey where Caesar fell. The theatre, which could hold almost twenty thousand people, is gone. It was still listed in a pilgrim guidebook written in the ninth century, but it had all but disappeared by the late Middle Ages. Its travertine marble facing was recycled for the facade of the Palazzo della Cancelleria; the red granite columns for the Basilica di San Lorenzo. But, in the streets between the Largo Argentina and the Campo de' Fiori, you can trace what may be the curve of the old arena, along the arm of the Via dei Chiavari. And, after enough visits, one sees oneself coming and going, drawn and redrawn on a tablet with an infinite memory.

What stays, and hovers in the air? In March 1334, the Italian priest, mystic, and cartographer Opicinus de Canistris became ill and fell into a coma, in Valenza. When he awoke two weeks later, his speech had deserted him, and he had lost the use of his left hand. When he was able to speak again, and to write and draw, he described a vision of the Madonna with the child in her lap. The Madonna, he said, guided his hand to draw a series of fantastical images. The fifty-two large colored parchments, which depict maps of the Mediterranean and the Italian peninsula, are now in the Vatican Museums. The land masses are enclosed within human figures who are often in conversation with one another. In the margins and across the seas, Opicinus covered the paper with cosmological signs, biographical notes, and iconography—an owl with a bent wing, a unicorn, a cat, a crucifixion inside the body of Christ, suns and stars. On one map the word "Roma" is written on a sea captain's forehead. A contemporary, the friar and mapmaker Paolino da Venezia, wrote that if a map is to be useful for navigation, what is needed is "a two-fold map, composed of painting and writing," for one without the other is useless. A cartography of the senses. Or, brushing up a little closer, Freud's dream of Rome, six hundred years later: "Now, let us make the fantastic assumption that Rome is not a place where people live, but a psychical entity with a similarly long, rich past, in which nothing that ever took shape has passed away, and in which all previous phases of development exist among the most recent." Almost no one has not had their

say. Jung, writing about Rome three decades after Freud: "If you are affected to the depths of your being at every step by the spirit that broods there, if a remnant of a wall here and a column there gaze upon you with a face instantly recognized, then it becomes another matter entirely."

A few days later, I take a train to the airport to meet Paco. Seated near me, a little girl plays patty-cake with someone who may be her grandfather, but the game descends into her slapping him again and again, until an elderly woman, in a fluorescent yellow blouse and a blue scarf covered with a pattern of silver stars, presumably her grandmother, asks her to stop. Next to her, the bare arms of a woman—the girl's mother?—are swathed in plastic wrap, to protect her new tattoos, a row of interlocking black hearts. It is rare to see badly behaved children in Italy. The older woman says wearily, under her breath, as if chiding the universe: *basta, basta, basta.*

It is ninety-six degrees. I have brought two bottles of water, one for each of us, as if, I tell myself with exasperation, there won't be water at the airport. The plane is delayed; it takes an hour for Paco's luggage to appear, and when I meet him, he has the surprised look of someone blinking in sudden sunshine. At the taxi stand at the airport, there is a press of people. The address is as unknown to the driver as a lake on Mars. Only at the words "Porta San Pancrazio" does light enter his eyes. "Ori siamo in affari!" Now we're in business! The suitcase is tossed into the trunk as if weightless, the taxi's air-conditioning, a rarity in Rome, is magically on.

We take the exit for Trastevere, and the driver makes his way through block after block of 1960s apartment houses, garrisons of pale concrete, animated by the terraces that Italians love, made luxuriant, choked with plants and flowers, as they rise to the coveted uppermost floor, where they are filled with palms and hanging baskets of tutti-frutti verbena. I look over at Paco, sweating already in his beautiful linen jacket. It was raining and forty degrees when he left London that morning. The driver is eager to deposit us by the Bar Gianicolo, so that he does not have to circle around the maze of one-way streets, past the Spanish embassy and San Pietro in Montorio. At the bar, a group of desultory, overheated German tourists, unsure why they have made the effort to climb the long, grown-over, garbage-strewn steps to the top of the hill, are drinking sour-orange Aperol spritzes, at tables half in and half out of the shade. It is only with coaxing that I'm able to persuade the driver to make a circle yet again past Bramante's Tempietto, just visible through the iron bars of San Pietro in Montorio, the curtailed view—like so many things, an almost impenetrable secret—of the Tempietto, the slim columns' arms, like a glimpse of nymphs through the trees.

Finally, we are in front of the gate to the house. I open it, holding my breath. In the heat, the lock often sticks, and it is too hot to stand around in the sun. While I waited for Paco at the airport, I thought about what it would be like to be meeting *lo spettro* instead. He never once met me at an airport, and did not like to be met

himself, as I do not now, having taken on some of his coloration, his knack of flitting around corners. But he would have stayed in an apartment that belonged to a contessa he had known as a child, or a studio that belonged to a third cousin, which is close to the bar that Pasolini liked so much. He would not have arrived and, climbing the stairs to the top floor, said, "How lovely."

"I sometimes fancy," said Hilda, in *The Marble Faun*, Nathaniel Hawthorne's Italian fantasia, "that Rome—mere Rome—will crowd everything else out of my heart." I am so accustomed to being on my own, or accompanied by a ghost, whose absence, since it is or was his city, magnifies its hold on me, that I barely know what to do with a visitor. Luckily, he has with him, ready at hand, his own pocket-sized Rome, which folds open to a map of a trip to Italy, made in a touring car with his mother, at age eight. The trip left an indelible impression of the perfect geometry of the Campidoglio, where, later that day, we perch on the steps and watch a bride, like a great Luna moth, cross the piazza, her attendants a flock of butterflies. In the early evening, we sit at a café table in the Piazza Farnese, drinking *acqua frizzante* with extra ice, where above us a giant fan moves the tassels on the striped umbrellas, but not much else. The chicest figures in the summer heat are the nuns from a nearby convent, the Order of Saint Bridget, in their gray habits, black girdles, and sensible black oxfords, like models in a runway show by Karl Lagerfeld. The day before Paco leaves, on our walk down to the city, we stop in at the Hotel Donna

Camilla Savelli, to see the seventeenth-century Borro-
mini chapel. After a rapt silence, he says, "I can go home
now." Which I find, in Rome, almost impossible to say.

Despite the incessant pulse of 1980s pop music, for which
Italians seem to have unlimited tolerance—here, from
the bar on a nearby terrace—in Rome, one sleeps like
the dead, and dreams one's dreams, as if the whir of the
overhead fan were a blade in a mixer in which all the
atoms, past and present, are combined. On a Sunday,
a week later, I wake at dawn. I have forgotten to close
the shutters, and the room is as bright as a studio. No
incubi here. Overnight, a colony of ants has appeared on
some cut lemons that I left out on a white plate. From
Trastevere below, an infernal noise, as if all the Vespas in
Rome suddenly exhaled, then started up again. *Vespa* is
Italian for wasp. The blare goes on for an hour until it
suddenly stops—a reprieve!—and then, just as mysteri-
ously, starts again. It drowns out the noisy parrots in
the umbrella pines, the fan set on the highest speed, the
white noise of the occasional car winding its way up the
Via Garibaldi.

It is the only cool moment of the day. I put on a white
dress like a tent for the heat, because anything grazing
the body is as disagreeable as an unwanted touch, not
caring that in the strong sunlight it will become almost
transparent. Time for a walk, the first of the day. In Rome
I am always unsteady on my feet; the cobblestones seem
to rise and wobble. After two weeks, every pair of shoes

hurts, including the thick-soled espadrilles that I buy on each visit. I carry a box of Band-Aids in my shoulder bag, for the blisters that develop in the course of the day, like a pilgrim whose feet are torn to shreds. Roman women, unbelievably, wear heels. No one but tourists wears sneakers. Nearby, in the park, the Villa Doria Pamphili looks like a bread box over the wall of orange trees. The grimacing caryatids on the parched fountain look half-mad, perhaps because the lower halves of their stone bodies are carved to look like fur rather than fins, as if they had emerged from the fountain neither beast nor fish, but something other, made of water and claws. A half mile in from the gate, a far glimpse of Rome through the trees, a series of sugar cubes, the top of the Vittorio Emanuele monument just visible. On the way into the park, I entered through the right arch; as I exit, I leave through the left. Or is it the reverse? It depends, of course, on how you look at it. By the gate, the tall trunks of the umbrella pines look like walking sticks in an umbrella stand, before they weave themselves together in a lattice overhead.

More than half a century ago, the American writer Eleanor Clark observed in her book *Rome and a Villa* that "in Rome to go out is to go home." Since it's Sunday morning, from the park I find myself heading down into Rome to retrace a private triangle. I start at Sant'Ivo, or more properly, Sant'Ivo alla Sapienza, near the Piazza Navona, only open to the public on Sunday between nine thirty and noon, to gaze up its spiral campanile: the effect,

always, is as if one is twirling from a great height in space, to land blinking in the courtyard. From there, it is only a moment's walk around the corner to San Luigi dei Francesi, where, at the rear of the church, Caravaggio's angel appears to Saint Matthew, hovering above the startled saint in a whipped-cream crenellation of tulle. Why does it stop my heart to know that the painting was given to the chapel in place of an earlier one, in which the angel sits on Matthew's lap teaching him to read? (The church fathers felt that Matthew should have already known how to read.) And that the earlier painting, taken by the Germans during the Second World War, was burnt to ash in an antiaircraft bunker in Berlin? The third point of the triangle is the Ludovisi Battle sarcophagus, housed nearby in the Palazzo Altemps. The melee depicted on its marble panels seems just to have begun or, perhaps, ended—a hand flung out, a soldier arching his neck to breathe, a horse stamped on by another soldier's boot heel. An entirely personal trio, from light to shadow to horror, beauty out of infinite terror.

This early, the tourists are still asleep or eating questionable breakfasts at their hotels and pensiones. When I come out of the museum and into the Piazza Navona, the bars and souvenir stands are shuttered. In winter, at Christmas, a scrim of snow shines in the streetlamps, and armed militia allow the crowds into the piazza one person at a time—almost everywhere in Rome, now, there is a bored-looking young man in uniform carrying a semiautomatic—and a merry-go-round circles like

a bejeweled crown. But it's summer, and pigeons thrust their beaks into piles of trash that a street sweeper is trying to capture in a plastic sack. When I mentioned to friends in New York that I was going to Rome, they said, "But I hear it is so dirty now," as if Manhattan floated on a white cloud. In the winter, the cold freezes the city in place, an icy daguerreotype; in summer, garbage swirls in the little eddies of wind over the grates marked SPQR, the bins outside the butcher shops overflow with offal, the flies a frenzied neon swarm. Weeds grow waist-high from cracks in the pavement. Everywhere, everyone says, "senza speranza"—hopeless.

One evening, I sat with a friend in her garden, in the cool. She said, "It is terrible about the city. For people who come here, to see it, it is one thing. For us, who live in Rome, it is another. It is disgraceful. And the worst of it is that we finally have a woman mayor, and she is terrible. Milan has just won the Olympics—the mayor here said she would not even try, because there would be no way in Rome to control the corruption. What kind of thing is that to aspire to?" But would my friend leave? No. She had been stroking the hair of her ten-year-old daughter, who was resting her head in her lap. She gave it a little yank, and the child looked up, startled. I learned that combination of sentimentality and harshness, first, from the ghost, who has by now almost completely disappeared, except for a shroud, draped over everything, a thin, inky mist—a kind of *tristesse*—that in the next moment, even worse, vanishes.

A shrug of the shoulders—*allora*, a word that means *then* or *so*, the equivalent of a pause, in Italy endlessly repeated, skirting between *and then* and *now what?* As a friend wrote, long ago, contemplating another city, more serene than this one; it is a mistake to make a meal out of one's emotional life. Better to feed off something else, or at least try. In the afternoon, at lunch with my friend Delia at Da Teo, in the Piazza dei Ponziani, we eat squid and fried artichokes, transformed on the plate into spiky autumn leaves. We talk about throwing things away— clothes, old letters, exercise bikes, ashtrays, houses—a thing that Rome never does, or can't. About her last love affair, she said, "It was good but I could see it would become bad, so I stopped it beforehand." Afterward, we went a few doors down, through an unmarked door, into a web of cool, where the apse of the tiny Sant'Andrea de Scaphis, Saint Andrew of the Little Boats, has been turned into a gallery space. The beamed ceiling is decorated with an installation by the American artist Laura Owens: a celestial map, in saturated shades of blue, and overlaid, like the Opicinus drawings, with gods and leopards, unicorns and a sprinkling of stars. The map was made in panels, then brought to Rome, and cut to fit the ceiling. The day before the opening, the lift, which enabled workers to paste the panels onto the ceiling, broke. "Un incubo!"—a nightmare!—says the gallery attendant, a girl who has come down from her glass cage above the entry, her blonde hair pulled back from her round face like a Madonna by Fra Lippo Lippi. At first, we hold the

mirrors she gives us in order to see the ceiling, but they make the images swim. Instead, we lie on our backs on the altar, gazing upward. Every so often, a tiny image—a unicorn, a pair of winking eyes, appears, then disappears, a dream in the corner of an eye, a visionary cul-de-sac. "What is *unicorn* in Italian?" I ask Delia. "*Unicorno!*" she says, and laughs. In the pictures we take of each other lying on the floor, we look like we are standing upright; when we rotate them, we fly through space.

A walk across the Ponte Palatino, the so-called English Bridge, because the traffic pattern is left-handed. For the visitor to Rome, it is almost impossible to understand the traffic patterns, which seem to reverse at will. Do the cars on the Lungotevere go south or north? In what direction does the tramway run on the Viale di Trastevere? Near the Piazza di San Cosimato, where a wall is painted with a hundred eyes, to ward off evil, I think I have it figured out and then step into oncoming traffic. As I do now on the bridge, and Delia yanks me back. The sun is so hot that we hold our breath, like firewalkers. Below, the yellow river shows signs of life as it funnels over the dam, past the Isola Tiburnia, where, crossing the other day to stop at the pharmacy to buy more bandages for my feet, I watched as a coffin appeared around the corner and entered a morgue—conveniently located across from a hospital, with a characteristic matter-of-factness—for after all, as every Roman knows, there is only one ending to every story. No city is as expert at making you remember that today disappears, nor that practically everything

here we know of the past has been learned from the tombs of the dead. And it's a peculiarity of the Etruscans that most of the inscriptions—on vitrines, bracelets, and goblets—read: "This was given to me."

By the Pantheon, in front of the Tazza d'Oro, a busy gelateria, the line snakes down the street. I order iced coffee granita swathed with cream, the almost-black shards of icy frozen soot burning on the tongue, tiny needles of cold. We circle back to the river, past city spigots where a queue has formed for a turn to throw cold water on the day's rigors. Delia's new love, Maurizio, who has written a book about Italo Calvino—who once wrote that "cities, like dreams, are made of desires and fears, even if the thread of their discourse is secret, their rules are absurd, their perspectives deceitful, and everything conceals something else"— is moving his ten thousand books from one flat in Prati to a new one. Tomorrow, she will help him, and I will sit at my desk, gazing at the emerald parrots, trying to keep myself from heading down the hill simply to go out, to be out in the dream of Rome, and instead think about why I am here, staring at the ceiling, reading Roman history, wishing my phone would ring—and sighing when it does.

After the granita, Delia and I turn left before the Ponte Garibaldi. In the courtyard of the Vicolo de' Catinari, which doubles as a carpark, is a huge seventeenth-century relief, festooned with putti, and beyond it, inside the Galleria Lorcan O'Neill, an installation by the British artist Richard Long. Two circles, measuring perhaps twelve feet across, one of white Carrara marble stones,

the other, dark Portoro stones, which look like they have been torn from a riverbed. The show is called "Fate and Luck." We are the only visitors to the gallery, perhaps all afternoon. The hush is profound, as though the cool of a tomb had been shattered and left here, in these discs of stone, each one the size of the smallest burial mounds at Cerveteri, near Civitavecchia. Are they the same, then, in this mortal city, fate and luck, or close enough to make no difference? As I write this, my fingers type out not "fate," but "faith." But faith in what? That I will be able to gather these loops together, the alpha and omega, in a city where it is impossible to put the ghosts of the past to bed, and even more impossible to relinquish just one?

There are days when the light shimmies off every gesture in the Piazza Navona, when the leaves in the Borghese Gardens are as still as jade. I don't have to remind myself that it is possible to be unhappy in Rome, to feel at each step the violence of the city, where the ragtag ends of desire and cruelty are bound by a brass ring. In a gallery in the Ghetto, an installation by the Italian artist Chiara Valentini: rows of scarecrows, made by crossed two-by-fours. Their black cloth faces are self-portraits by asylum seekers sponsored by the Italian Red Cross. Each one is dressed differently. One wears a striped shirt, another, a suit jacket, a third, blue trousers and a T-shirt. The first scarecrows in Rome were carved figures of Priapus, born deformed after Juno, a patron goddess of Rome, jealous of her beauty, cursed Venus before he was born. As you near the scarecrows in the gallery, ducking

and weaving between, they are activated by an electronic system. When you veer away, they fall silent.

On the way home, the taxi driver turns onto the Via dei Banchi Nuovi. Not the Via Garibaldi, I ask? No, through the Gianicolo, where it will be cooler. It is dusk as we approach the overlook, where every Sunday morning and afternoon at the Teatrino di Pulcinella, Judy, in a bright red dress, regularly bangs Punch over the head, while grandparents, infants in prams, tourists in abbreviated shorts gripping water bottles, keen with laughter. At 10 p.m. the overlook is packed with people seeking a breeze. The driver stops suddenly and gestures out the window at the view. "Bello," he says, "sempre bello." The lights on the hills are like fireflies in the dark, the city like a reflection of itself in water, and I think of the laughing caryatid at the fountain, earlier this morning, at the Doria Pamphili, half fish and half fur. In Rome, time itself moves at once backward and forward, every glance and footstep written and rewritten on the skin of the city, a skin that rather than shedding, accretes; an old snake with glittering eyes. As the driver loops up to the Piazza di San Pancrazio, I see myself walking down the road to the glassy Tiber, in a green dress, light as gauze, that I left behind this summer, that I now miss. That summer, the ghost and I did not speak, and I tried to learn the city with my feet. "Knowledge of Rome must be physical," writes Bowen. Like most things. After a while the ghost one knows too well is oneself.

A friend from New York is here on his own for a week, and we meet most nights for supper. We stop to look at the Tiber on a Tuesday evening, as we make our way back from an *aperitivo*, at Vino Olio, a bar he likes on the Via dei Banchi Vecchi, for dinner in Trastevere. I tell him that when I came for a night in April, I stayed nearby, on the Via Giulia, in a room with a little balcony. I had only the morning and early afternoon, before my plane, and I found myself disoriented, unable to make my way to the Piazza di Spagna, where I wanted to replace a pair of gloves that I had bought there and then lost on a wintry, wet day in London. I traced a confused circle until I realized that rather than staying, as usual, in Trastevere, I was on the other side of the river, and could find my way, without crossing a bridge, to the glove shop. It was Good Friday, and the Spanish Steps were covered with pots of pink and white flowers, rising over the silvery calligraphy of the Fontana della Barcaccia.

Rome is full of rising and falling. When the Tiber overflowed on Christmas Day, in 1598, an event that is marked with a plaque at the height of the flood-line on the facade of Santa Maria sopra Minerva, behind the Pantheon, a carved hand pointing to a turbulent river, a boat drifted into the Piazza di Spagna—Bernini, commissioned by the pope, based his design for the fountain on that watery event. Even though it was Good Friday, every shop was open—the Romans are pragmatists to the one, uninterested in stopping the river of euros on a good week for tourists. To the right of the steps is the door that

opens to the rooms where Keats died, on a green bed so small it is hard to imagine it holding a full-grown man, rather than a child. Last winter, I'd been in the Piazza di Spagna, in Rome for a week, with my youngest daughter. As I stood in the piazza I saw, like a series of stereopticon slides, shown at this spot, precisely, one image over the other: my daughter, through the window at Valentino, trying on a long-sleeved red dress, the skirt gored like an upside-down tulip, the glass scaled with frost. Then, through a trick of light, another girl the same age, at nineteen, who would improbably become her mother, hair down to her waist, in a white dress covered with Mexican embroidery, hot, tired, exasperated by her travel companions, but suddenly and inextricably in love. *Bright star, would I were steadfast as thou art.* Her eye is fixed not on the boy beside her, who has brought her here, with whom she would quarrel and from whom, two years later, she would part, but on the starburst geometry of the streets converging, the hum of the pigeons, the hawkers, and the sun on the spumes of the fountain, the falling water that Keats heard from his deathbed. It is hot on the steps; the stones burn through her thin dress. This is her first time in Rome. The next time, it will be without him. Years later, she will go to Keats's grave, in the Protestant cemetery, and a small gray cat will sidle out from between the stones and sit in her lap.

At the glove shop, I recognized the blonde woman who stood in front of the display of red, blue, green, and yellow disembodied hands reaching to the mirrored ceil-

ing. But to her I am faceless, my palm one of thousands stretched across the counter to which she gives a practiced eye. In a city in which leather goods fill every other shop, I have only bought gloves, and only here, as if asking the city, again and again, to hold my hand. I explained that I have lost my gloves, which I had bought at this very shop, three years ago, with what I hoped was a fair imitation of an Italian look of mixed helplessness, despair, and desire. She was entirely uninterested. No handholding, here. Instead, she takes out a cylinder in which cashmere-lined gloves my size are packed like sardines, and chooses a midnight blue pair with a leather bow covering the long gauntlet. "Bello, si?" she says, seizing my hand in a rote gesture of affection. Now, she could be my aunt, or my *nonna*, or my best friend. She's eager to sell them—midnight blue is less popular than black—and, I happen to know, this model is left over from two winters ago, or it is three? The winter when, on the way to a restaurant in the East Village with the ghost, I left another pair of gloves in a taxi, and a few days later, he took me to this shop's twin, in New York, and bought me an identical pair, in emerald green. In Rome, there is always the ghost of a ghost of a ghost. In the end, not an unusual story.

As we pause on the bridge, looking upriver toward the Castel Sant'Angelo, which looks like a huge nautilus shell in the gloom, my friend from New York laughs at this story. This evening, the river is concretized, barely riverine, yellow, but at least moving. A sculler moves downstream, like a figure in a painting by Lorenzetti. The

origin of the Tiber is two springs in the Apennines, tucked into a beech forest. Mussolini changed the border, between Tuscany and Emilia-Romagna, so that the start of the river would flow from his birthplace in Romagna. The name of the river is elusive. When Tiberinus Silvius, ninth king of Alba Longa, drowned in the river, in 914 BC, it was called the Albula, either because of the white sediment that came down from Mount Fumaiolo, *alba*, or for the pre-Indo-European word for an elevated plain, *albion*. After the drowning, the river was named for Tiberinus. Or was it? The root of "Tiber" also means "river weed," the early word *dubris*, or "water." So perhaps the river was returned to its namesake, water? The old names of the river are a shimmer of sound, just out of reach but infinitely desirable, the radio dial a stylus, barely on track, that forms, like the Italian language itself, the best patois in the world for endearments, the endless -*issimo*s and -*ina*s. On my walk down to the city this evening, I took the back way, past the garage on the Vicolo del Piede, and remembered the man with his little brown-and-white dog, two summers ago, who paused by the open door, a man who spoke tenderly to his dog in a voice even I could understand. The morning before the ghost disappeared, for what would be the second-to-last time, he taught me, going around the room, the names for everything: wall, ceiling, curtain, baseboard, sheet, blanket, bed, chair, desk, pillow, door, so that I would know exactly how to speak to the space he would leave. *Muro, soffitto, tenda, battiscopa, foglio, coperta, letto,*

sedia, scrivania, guanciale, porta. Language, Bowen says, never fails quietly. It fails noisily.

Shadows gathering on the bridge, dappling the bright clothes of tourists leaning over to take photographs, and the accordion player, this evening, despite the heat, inexplicably wearing a kilt. The foot traffic slowed. We made our way around the Piazza Trilussa, where in the half dark, a crowd listened to an Italian reggae band. The young woman who holds out a palm for coins at Santa Maria in Trastevere sat on the steps, her feet bare and filthy, her head under a soiled bandanna, her face turned up to the music and the moon. A little girl twirled in front of the speaker, rapt, her dress the color of a lemon candy wrapper. At the restaurant, Zi Umberto, chaos. They are overbooked, they have a table, the table for four, it is for two. The right leg was balanced on a matchbook. We sit at the table cantilevered over the cobblestones. It is ten in the evening, a couple at the next table wants only dessert. The answer is no. I am talking about the ghost, and my friend interrupts me. "You know, you'll never get over it." And then, "Have you blocked his number? That's the key thing." Around us, Roman women in various stages of undress vied for the attention of the waiters. Weeks later, when I return to New York, I will button the button of my dress I leave open in Rome.

Rome is a city of unrequited passions, of things going wrong, of streets that head nowhere that once headed somewhere, of ruins and headless statues. *La storia si*

ripete, or, the story repeats itself. Or, as Bowen wrote, "Experience isn't interesting until it begins to repeat itself. In fact, till it does that, it hardly is experience." When does one know it is time to leave, what clockface names the hour? Rome is a city of churches, but not of clock towers. It is almost impossible, as Bowen says, to make the rounds of the churches, or even to list the endless procession of saints, but it is even more impossible to do what I want, which is to know in every detail each statue, monument, piazza, stone; to be better educated in the quattrocento, or the history of the Palatine, or the different varieties of travertine.

Instead, in Rome, I lie down after lunch, there is no help for it. In the midafternoon, the gates on the shops have come down, sparrows are picking at crumbs under the tables in the trattoria while the waiters sweep up, a broom in one hand and a cigarette in the other. In bed, my arms crossed above my head, I imagine myself in a drawing by Opicinus: my forehead in the Gianicolo, my body crossing the river to the Via Nazionale, and in the valley between my knees the Borghese Gardens, where Bernini's Daphne, fleeing, is forever turning into a rustling welter of leaves, and beyond that, the Villa Ada. A map of a corporeal city, in which the body is imposed, as it traces a route around and around the piazzas, crossing and recrossing the bridges. In Rome, one is at once the spider, the web, and the fly. By four it is equally impossible not to go out again in the city, and then, by six, the day says "Enough!" The Italian, *basta*, which means so

many things, including for a day, or a moment, simply the inability to go on.

And then one finds oneself in retreat to the bar under a canopy in the Palazzo Farnese, or, better, the dim paneled recesses of the bar at the Hotel d'Inghilterra, where sixty years ago Elizabeth Bowen despaired of the dead time in the Roman afternoon, the oblivion hours when nothing can be done, or seen, or, in the torpor, even thought. At the bar on a last day in June, escaping from the heat, I settle down with my book. My only companion is a woman, dressed in denim pierced with metal studs, holding a lap dog, who spends an hour on her phone, arguing quietly with someone who seems to be her brother, about the bills he has run up at a house they share in Puglia. The aim of a day of walking is to be engulfed, a contest of wills that leaves one of the contestants vanquished. A guess to say which one. As if one could somehow wed oneself to the city. Useless, whether to a city or the beloved. Enough! But then one returns with an excuse, a lost glove, a second thought, or, barring that, one gives up, and cruises the streets like a flaneur.

A Thursday evening, 9 p.m. Almost everything is closed. Calm on the Via Giulia, which draws me almost every evening, where the lion's-head fountain spews water in the dusky twilight, steps from the arch designed by Michelangelo, an abandoned plan meant to be part of a bridge over the Tiber. Diagonally across the river is the

Regina Coeli prison, used by the Nazis as an internment site, where tourists walk oblivious below the barred windows. Up the street is the church of Santa Maria dell'Orazione e Morte, charged with collecting the bodies of the vagrant dead. The exterior is etched with crouching skeletons; there is a brass slot in which to leave money to bury the poor. What is it about this place that holds me, as if in the cupped palm of a hand? The oblong between the Via Giulia and where the Via di Monserrato becomes the Via dei Banchi Vecchi—what recommends it? A nameless piazza full of cars. Yet each time I pass, I stop in silence at the house fronting the street, the small one with gray shutters, as if, just there, another life, one that belonged to me, was going on under the pitched roof.

It was so difficult to give up the ghost because I thought that there was another life we were meant to live, here, perhaps, where the golden light in the evening pours out onto the candy shop, where one or two tables are usually precariously perched on the cobblestones. Closed tonight. And above it, a top floor with a round casement window, big enough for the Vitruvian man to stand upright, and a terrace above that, crowned with heliotrope, the red blossoms like trumpets. In Italy, to fail at something, to draw a blank, is *a buco nell'acqua*. A hole in the water. It is my friend's last night in Rome. At the trattoria next door, the waiter refuses us a table, even though we say, "Just one drink?" Five or six tables are unoccupied, but everything, he says, is *prenotato*. Reserved. Resigned, we find a wine bar with an empty table

and two stools, and drink green *vernaccia* and gobble peanuts, brought out after a time, in a tiny dish on a tray.

On the way back to Trastevere, outside the *antimafia* and *antiterrisimo* building, we pass a huddle of soliders in camouflage, holding semiautomatics. A few doors down, teenagers pass around a cigarette. In Rome, walking with a companion, the unspoken contest is: who knows the street better, or who loves it more? Because we think, still, that love is proprietary, despite everything we have learned from history, our own and a continent's, about vanishings, varnished until they shine. At the tiny restaurant behind the Via Garibaldi, the scatty, good-humored waitress, her platinum hair in a top-knot, forgets, in succession, to bring the water, the wine, and then forgets entirely about the second course, rabbit in garlic, which she herself has recommended. She is distracted by her boyfriend, who arrived on his motorcycle and sat down at a table marked "reserved," on whom she has been waiting hand and foot, caressing his dark head as she walks by, as he eats a plate of pasta piled high as a pyramid, not saying a word.

To E., in New York:

A note to say, well, it is still hot and getting hotter. All the keys stick in the locks. It turns out I am going to return to New York earlier than planned—this Sunday. It's a case of ladybird, ladybird, fly away home.

It's so hot that I can only walk in the morning at the Doria Pamphili, even the dogs insist on walking in the shade. And a new fad for walking with ski poles, hilarious to anyone from a country where it actually does snow, as if they were poking their way along their own private arctic, through the dusty leaves. But as I've come to the conclusion that everyone's Rome is their own, a mapped and delineated interior city, perhaps it's par for the course—

Ci vediamo presto—

C.

On my last day in Rome, at the Museo di Roma, in the corner before the Piazza Navona, an exhibit of the first, early photographs of Rome. The marshy Tiber, without a bank, the Forum half unearthed, as if the city's ghost outlines were revealed, the blueprint of the past its fingerprint. And then on one of the photographs, like a conversation overheard but not remembered, a time-lapse image of a carriage just grazing the known world in the Piazza del Popolo, its motion caught and overlaid on the photograph even as it disappeared, like the image of the ghost, an *imago*, his voice caught on the phone on the one message I have not erased, so that with the press of a finger, the past can speak at any time. As it does anyway, with or without the ring of the *telefonino*, in the walls of this city, in the words we use for telling stories.

On the way back from the museum in the early evening, I go to Giolitti for a gelato—*fior di latte*—and then a focaccia on the Campo de' Fiori, as if to swallow last bites of the city whole. And then I stand for a time in the Piazza Trilussa, where the usual crowd of tourists and locals packs the steps. The girl with bare feet has somewhere found some shoes, and her hair is combed and pulled back from her suddenly beautiful face. The first notes of "Wild Horses" rise from the speakers the singer has set up in the piazza. A boy goes by on his father's shoulders, wearing a football jersey, waving a paper Italian flag. On my phone, a message from Paco, who is in Chile, with a photo of a volcano. The world opens and contracts to a pinhole. Two years ago, after a truck attack mowed down pedestrians in Nice, a crowd gathered here in silence, some weeping, as this same singer played "Imagine." He looks older, a little more grizzled, like the statue of Marcus Aurelius in the Campidoglio, playing for coins, or for free, in the waning twilight.

Confine yourself to the present, Aurelius says. How many tenses can there be? The past, perfect and imperfect. The sky over the bridge is watered silk, a Caravaggio sky, full of darkling clouds, streaked with green. In Rome, said Bowen, the sun is the yellow of white wine. If I sit here very still, on the fourth step to the left—or is it the right?—I can draw a line up the hill to Monteverde, and from my right shoulder to Santi Giovanni e Paolo; to the left, the Vatican and the quartiere Flaminio. Head, shoulder, knee. *Testa, spalla, ginocchio*. Words I learned

from a ghost. Pinned here in a city ruled by the spirits, as though if I sat long enough—there is the little girl again, wearing a blue dress tonight, not a yellow one. Do they come every evening?—I could discover the mysteries of the universe. Impossible to end elsewhere. O my darling.

ACKNOWLEDGMENTS

For time shared in Venice and in Rome, thanks to Andre Aciman, Owen Andrews, Chiara Barzini, Helena Fitzgerald, Massimo Nunzi, Dragana Nikolic, Jenny Oliensis, Carlo Pizzati, Nader Tehrani, Umberta Telfener, John Tygier, William Wadsworth, and my daughters Rose and Beatrice. To Virginia Cannon, peerless editor and friend. To Sophie Haigney, and to Beth Gordon and Lucas Zwirner, for shepherding this small book. And to The American Academy in Rome, for a vantage point.

"Ekphrasis" is traditionally defined as the literary representation of a work of visual art. One of the oldest forms of writing, it originated in ancient Greece, where it referred to the practice and skill of presenting artworks through vivid, highly detailed accounts. Today, "ekphrasis" is more openly interpreted as one art form, whether it be writing, visual art, music, or film, that is used to define and describe another art form, in order to bring to an audience the experiential and visceral impact of the subject.

The *ekphrasis* series from David Zwirner Books is dedicated to publishing rare, out-of-print, and newly commissioned texts as accessible paperback volumes. It is part of David Zwirner Books's ongoing effort to publish new and surprising pieces of writing on visual culture.

CYNTHIA ZARIN is the author of five books of poetry, most recently, *Orbit* (2017), as well as five books for children and a collection of essays, *An Enlarged Heart: A Personal History* (2013). Her honors and awards include a Guggenheim Fellowship for Literature, the Ingram Merrill Award, and the Los Angeles Times Book Prize for Poetry. A longtime contributor to *The New Yorker*, Zarin teaches at Yale University.

OTHER TITLES IN THE *EKPHRASIS* SERIES

Two Cities
Cynthia Zarin

Published by
David Zwirner Books
529 West 20th Street, 2nd Floor
New York, New York 10011
+ 1 212 727 2070
davidzwirnerbooks.com

Managing Director: Doro Globus
Editorial Director: Lucas Zwirner
Sales and Distribution Manager:
Molly Stein

Project Editor: Elizabeth Gordon
Proofreader: Kathleen Cook
Design: Michael Dyer / Remake
Production Manager: Jules Thomson
Project Assistants: Claire Bidwell,
Elizabeth Koehler
Printing: VeronaLibri, Verona

Typeface: Arnhem
Paper: Holmen Book Cream,
80 gsm

Publication © 2020
David Zwirner Books

Text © 2020 Cynthia Zarin

Distributed in the United States
and Canada by
Simon & Schuster, Inc.
1230 Avenue of the Americas
New York, New York 10020
simonandschuster.com

Distributed outside the United
States and Canada by
Thames & Hudson, Ltd.
181A High Holborn
London WC1V 7QX
thamesandhudson.com

ISBN 978-1-64423-031-2

Library of Congress
Control Number: 2020901921